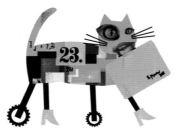

ILLUSTRATED BY
NIA GOULD

WRITTEN BY DIANA VOWLES AND JOCELYN NORBURY
EDITORIAL CONSULTANCY BY THOMAS YEOMANS

EDITED BY JOCELYN NORBURY
DESIGNED BY JACK CLUCAS
COVER DESIGN BY JOHN BIGWOOD

First published in Great Britain in 2019 by LOM ART, an imprint of
Michael O'Mara Books Limited, 9 Lion Yard, Tremadoc Road, London SW4 7NQ

 www.mombooks.com/lom
Michael O'Mara Books
@OMaraBooks
@lomartbooks

A CIP catalogue record for this book is available from the British Library.

ISBN: 978-1-910552-90-2

2 4 6 8 10 9 7 5 3 1

Printed in November 2018 by Leo Paper Products Ltd, Heshan Astros
Printing Limited, Xuantan Temple Industrial Zone, Gulao
Town, Heshan City, Guangdong Province, China.

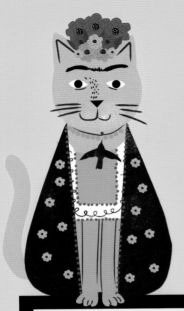

A HISTORY OF ART
IN 21 CATS

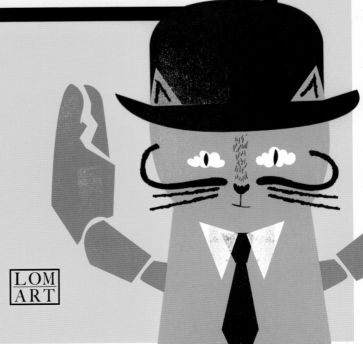

LOM
ART

INTRODUCTION

Felis catus, better known as the beloved house cat, has been a valued human companion throughout history. It is a symbol of culture and refinement, capturing the imagination of the ancient Egyptians, who held cats in the highest esteem. Feline friends have stalked the studios of many artists, such as Pablo Picasso, Claude Monet and Georgia O'Keeffe. So, it seems entirely fitting to enlist 21 cultured cats to navigate a journey through art history.

From ancient Egyptian and Byzantine art to the wacky and wildly successful world of the Young British Artists, explore the styles that characterized important art movements and the artists who led them.

The elements used to create the 21 felines featured come with an explanation of how they reflect the work of a particular artist or an aspect of a movement. Why not use these elements to develop your own creative 'cattitude'?

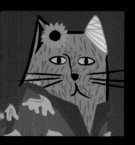

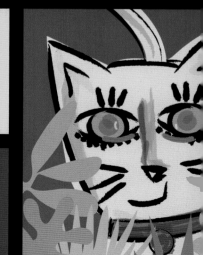

There's a timeline at the back of the book for an at-a-glance
guide to the artists and movements featured.

ANCIENT EGYPTIAN

This cat's air of haughty self-importance and regal disdain was typical in ancient Egyptian art. Cats were associated with various gods and their likenesses were preserved as sculptures and amulets and seen in wall or tomb paintings.

Rather than serving a decorative purpose, Egyptian art was used to convey spiritual meaning. Much of it reflects the people's belief in life after death. The images that appeared on tombs and murals were very stylized and made no attempt to show realistic likenesses, either feline or human.

Egyptian artists indicated the rank and importance of the people they depicted with the colours that they used and with the sizes of figures in relation to each other. Anyone observing this cat would instantly identify it as a god rather than a humble mouser.

Often, the intended audience of a tomb painting was the dead person themselves. The pharaoh who found this picture on their tomb wall could rest assured that their feline friend would accompany them into the afterlife – that is unless the poor cat had been killed, mummified and buried beside the deceased despot.

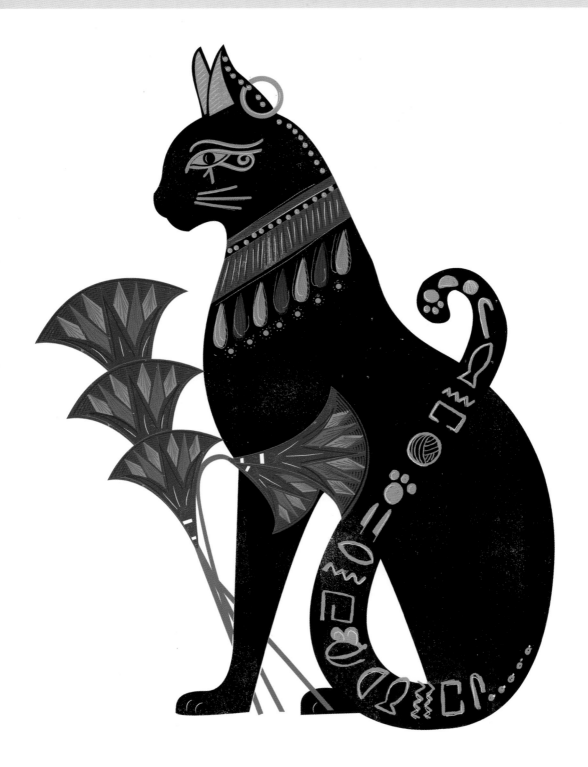

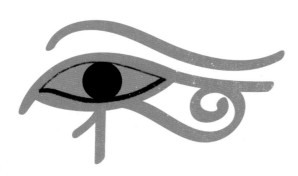

ELABORATE EYE

This style of eye, seen in much Egyptian art, is called the Eye of Horus. A symbol of protection and good health, it was believed to embody magical powers. It appears in depictions of Wadjet, an early Egyptian deity, but was originally found on Horus, the falcon sky god.

COLOUR PALETTE

Ancient Egyptian artists mainly used a palette of six colours: red, green, blue, yellow, black and white. Each colour had its own symbolism, and the colours had to be taken in context – the proud black cat here is a symbol of regeneration and rebirth.

'You are the Great Cat, the avenger of the gods, and the judge of words, and the president of the sovereign chiefs and the governor of the holy Circle; you are indeed the Great Cat.'
Tomb inscription in the Valley of the Kings

LOTUS FLOWERS

The lotus was one of the most important ideological symbols used in ancient Egyptian art. Lotus flowers open in the morning and close up at night, so they were associated with death and rebirth. They were also used to symbolize the sun.

ALL THAT GLISTENS ...

Gold was highly prized in ancient Egypt because of its association with the light of the sun and the solar deity, Ra. It was also linked with the idea of eternal life because of its durable quality. Artists used it extensively in works created to honour nobility.

JEWELLED COLLAR

The ancient Egyptians placed great emphasis on jewellery and physical adornment. Jewellery was worn by men and women of all social statuses to ward off ill health and bring good luck. The most recognizable piece is the broad necklace, here given a new lease of life as a jaunty collar.

HIEROGLYPHIC TAIL

Egyptian hieroglyphs were the formal writing system used in ancient Egypt; the 'letters' could be considered works of art in themselves. This ancient Egyptian cat is using hieroglyphs to depict some of its favourite things.

What do colours mean in Egyptian art?

Red: life, destruction
Blue: new life, fertility
Green: goodness
Yellow: the sun, eternity
White: purity, sacredness
Black: death, the underworld, resurrection

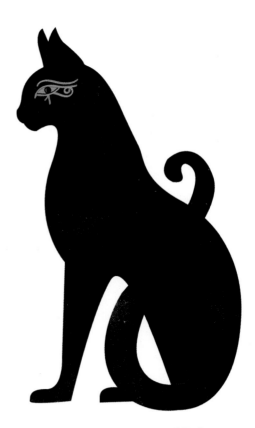

POINTS OF VIEW

Figures were shown both in profile and front view, so while this cat is viewed from the side the whole eye can be seen. Having as much of the figure showing as possible was thought to be essential for passing into the afterlife.

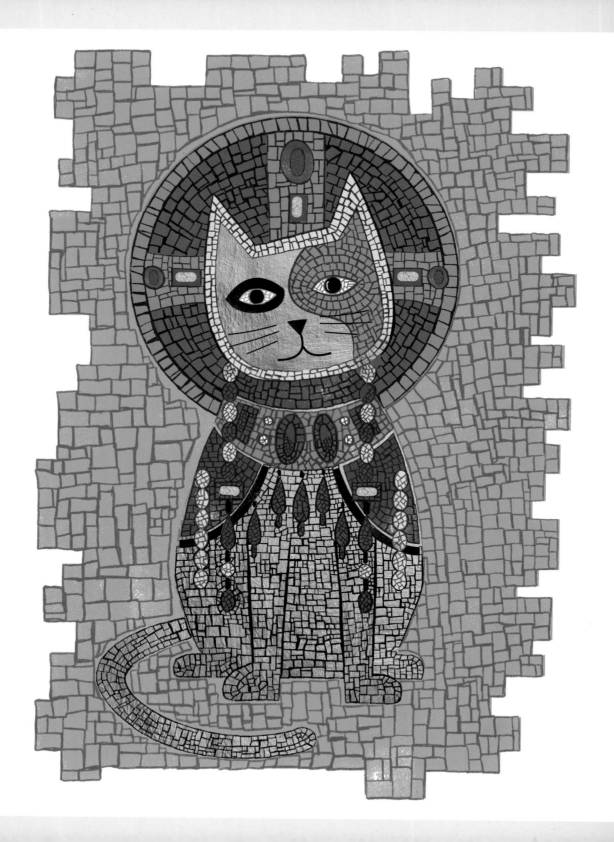

BYZANTINE

Bathed in a flickering light-play created by a thousand church candles, this Byzantine cat stares out of its golden surroundings. Its stylized, spiritual features are made up of a magnificent mosaic of tiny, glazed ceramic tiles.

The Byzantine Empire (330CE to 1453) lasted over a thousand years, and its boundaries changed endlessly, yet the style of its art remained remarkably consistent throughout. As it was a continuation of the Roman Empire, it is not surprising that the art of Byzantium was based on the art of the Roman and Greek classical eras. Yet it also developed its own aesthetic, reflected in the symbolic and abstract representation of this cat.

Many moggies are pampered and adored, worshipped even, which befits the devotional nature of this image and the use of gold leaf, which was a familiar feature of Byzantine art.

BITS AND PIECES

Mosaics were the most widely used form of pictorial art in the Byzantine period. This method enabled artists to work with different materials and textures, often choosing light, shimmering materials, such as mother-of-pearl, to give their work an ethereal quality.

BLING THING

Art of the Byzantine period is often adorned with glittering gold. This was used by artists as another way to catapult earthly beings into the realms of the spiritual. The shimmering reflection of candlelight would give the subjects of the art an otherworldly glow.

HALO

This symbol appeared in the late Byzantine (1261-1453) period as it had previously been associated with paganism. Later, it was used to emphasize holiness, and many emperors were depicted in front of this radiant nimbus.

In Byzantine art, symbolism took precedence over realistic depictions of subjects.

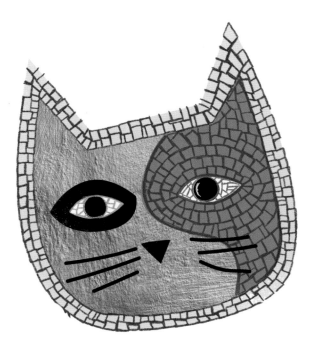

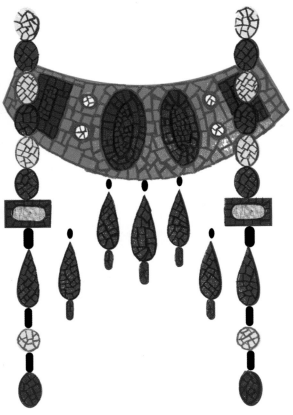

PENETRATING GAZE

Faces were stylized in Byzantine art. They generally featured serious expressions and exaggerated features, which did not necessarily aim to reflect real-life appearances. This was because artists were concerned with placing their subjects in a spiritual, rather than an earthly, sphere.

JEWELS

Jewellery was used on a very grand scale in Byzantine art, particularly when depicting sovereigns. It was a way of signalling importance – the more elaborate, the better. There were even explicit rules about the types of jewellery that could be worn – sapphires, emeralds and pearls were only allowed to be worn by an emperor, while any free man was entitled to wear a gold ring.

Byzantine mosaics were made from small ceramic tiles, usually around one centimetre wide, gilded in gold or glazed with colour. Glass pieces were incorporated for added sparkle.

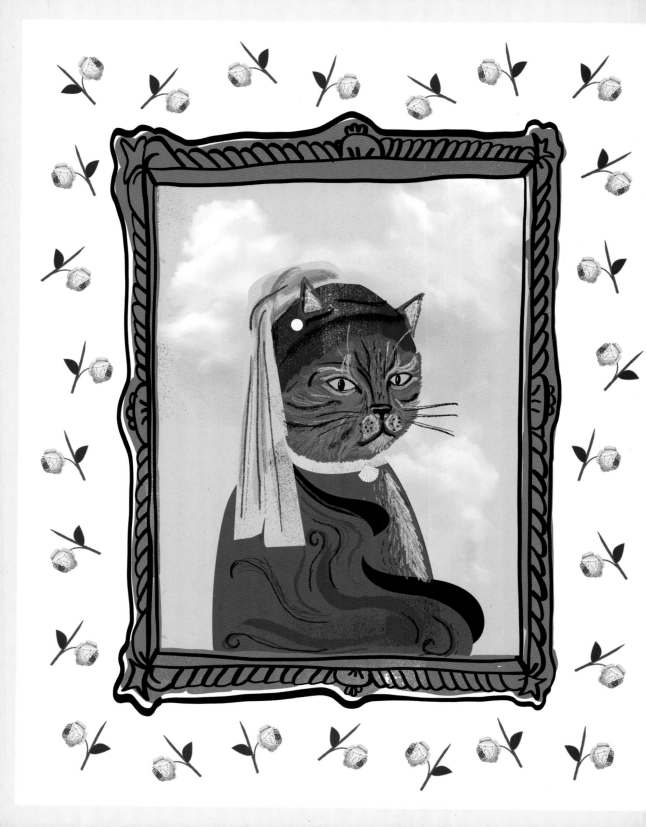

RENAISSANCE

The *Mona Lisa* is certainly one of the most visited and valuable paintings in the world. It is also the most frequently parodied. With an enigmatic look worthy of *La Gioconda* herself, this cat-in-a-hat typifies all things Renaissance.

The word 'renaissance' means 'rebirth' and refers to an exciting period in the history of European art, science, music, literature and philosophy. It was a time when a re-examination of classical Rome and Greece was combined with new technology, political stability and prosperity. It coincided with the lives of some of the greatest artists ever known, including Leonardo da Vinci and Johannes Vermeer, from whose paintings this early cat selfie takes inspiration.

Renaissance art was concerned with realism. The accurate depiction of an individual human or feline was more important than traditional religious imagery. Artists, such as Michelangelo and Titian, began to use new techniques to depict three-dimensional forms.

Though Renaissance styles varied from city to city, the artists' overriding aim was to represent even the most mundane details realistically, from milk on whiskers to scars sustained in a cat scrap.

EVERY CLOUD HAS A SILVER LINING

Light-filled, textured skies can frequently be seen in Renaissance art, often as a backdrop to heavenly beings, such as cherubs. These skies combined perspective, light and movement to dramatic effect.

VERMEER PEARL

A painting from the Dutch Golden Age, Johannes Vermeer's *Girl with a Pearl Earring* was not meant to depict any particular individual, but instead was intended to show off the artist's expertise in using light to create form.

MASTERING TECHNIQUES

Huge advances were made in both painting techniques and materials. Artists experimented with oil-based paints, mixing powdered pigment with linseed oil to ensure the paint took a long time to dry. This meant they could work on their pieces over a long period of time, adding layers and reworking to achieve distinctive depth and textures.

ON THE FACE OF IT

Portraits of women were very popular in Renaissance art. They were almost always painted in profile or three-quarter profile, and it was normal to keep facial expressions and emotions enigmatic. Beauty was used to imply goodness, so we can determine that this pretty pussycat is very virtuous indeed.

'A man paints with his brains and not with his hands.'
Michelangelo

'Painting is poetry that is seen rather than felt, and poetry is painting that is felt rather than seen.'
Leonardo da Vinci

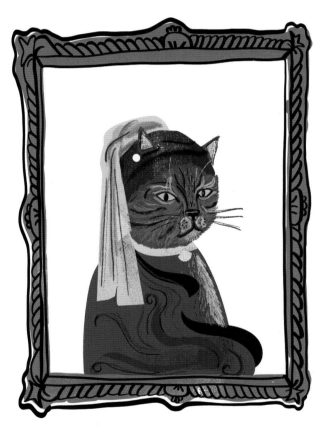

ROSES

Renaissance art was heavy with symbolism. Flowers in particular were used to convey all sorts of hidden messages. This romantic cat is using roses to convey feelings of true love.

ELABORATE FRAMES

The signature ornate gold frames that frequently surround Renaissance paintings could be considered works of art in their own right.

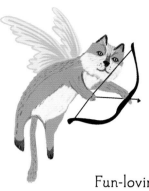

ROCOCO

Fun-loving felines would have found the Rococo period utterly heavenly. Compared to the austere style of earlier art, this new movement featured brighter, more vibrant colours, flowing lines and a general feeling of youthful exuberance.

Artists, such as Jean-Honoré Fragonard and François Boucher, captured the playful curvaceousness and sensuality of their subjects. Boucher had the most prominent success, becoming the favourite artist of Madame de Pompadour, the mistress of Louis XV and (disappointingly) a famous dog lover.

Artist Jean-Antoine Watteau became the master of the *fête galante* – the 'courtship party' – which showed idealized social gatherings in idyllic outdoor settings. How could a cat look more purr-fect?

Although it was born in France, Rococo style spread throughout Europe. In England, it influenced the technique of William Hogarth – yet another who favoured canine companions – and the fashionable portraits painted by Thomas Gainsborough.

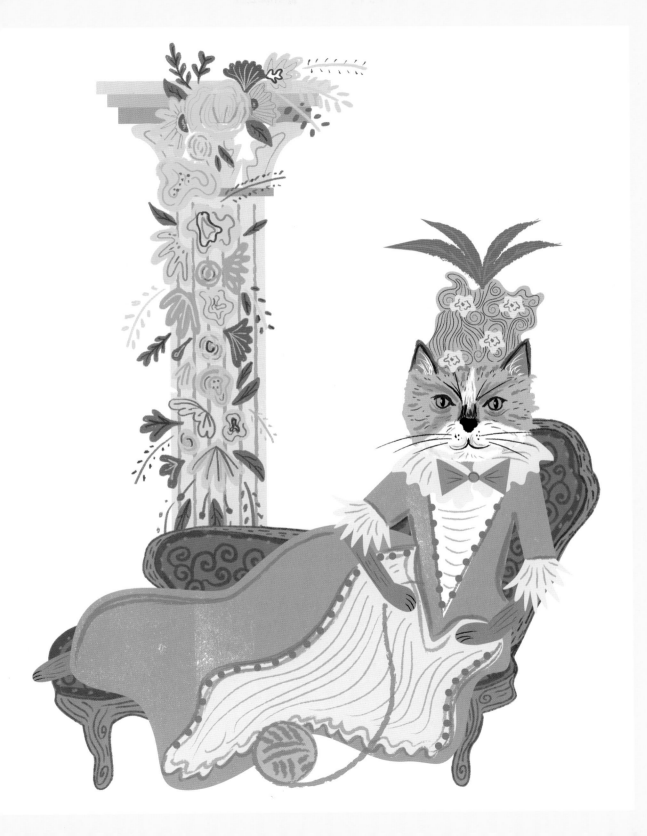

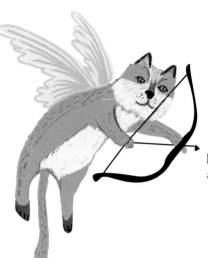

BOUCHER CHERUB

François Boucher had a liking for distinctively plump cherubs, and he was said to favour his paintings featuring them over his more famous works.

PASTEL PALETTE

The colour palette in Rococo art was often characterized by soft, pastel colours, celebrating romanticism and a move towards more light-hearted subject matter.

PLAYTIME

A common subject of Rococo art was people enjoying themselves, offering a sense of frivolity. Paintings often depicted garden parties and other social occasions, celebrating youthfulness and fun.

FLOWERS

Rococo artists, such as Jean-Antoine Watteau, painted elaborately decorative scenes, with lots of detail. Flowers stood for all that was decadent and luxurious in society.

CHAISE LONGUES

Furniture that appeared in Rococo art was generally decorative, often with ornate curves and carvings. This chaise longue demonstrates the wealth and opulence of the period, and is the perfect place for this pampered puss to stretch out.

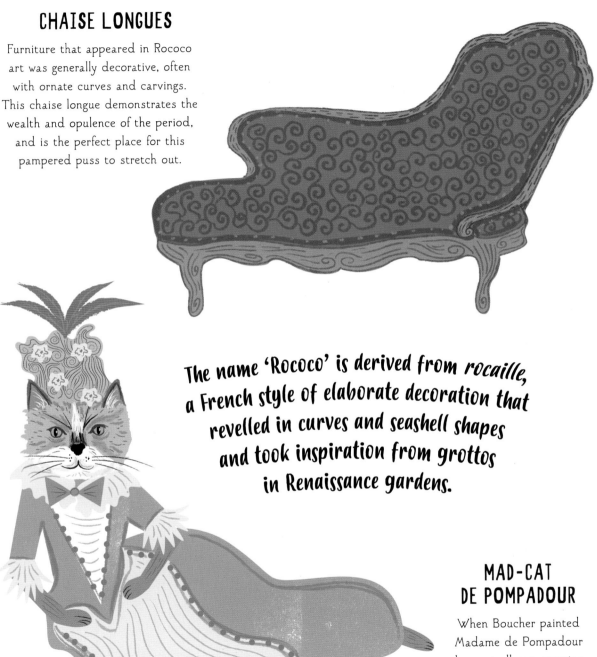

The name 'Rococo' is derived from *rocaille*, a French style of elaborate decoration that revelled in curves and seashell shapes and took inspiration from grottos in Renaissance gardens.

MAD-CAT DE POMPADOUR

When Boucher painted Madame de Pompadour he went all out, creating such a scene of luxury and sensuality that his picture became archetypal of the Rococo period.

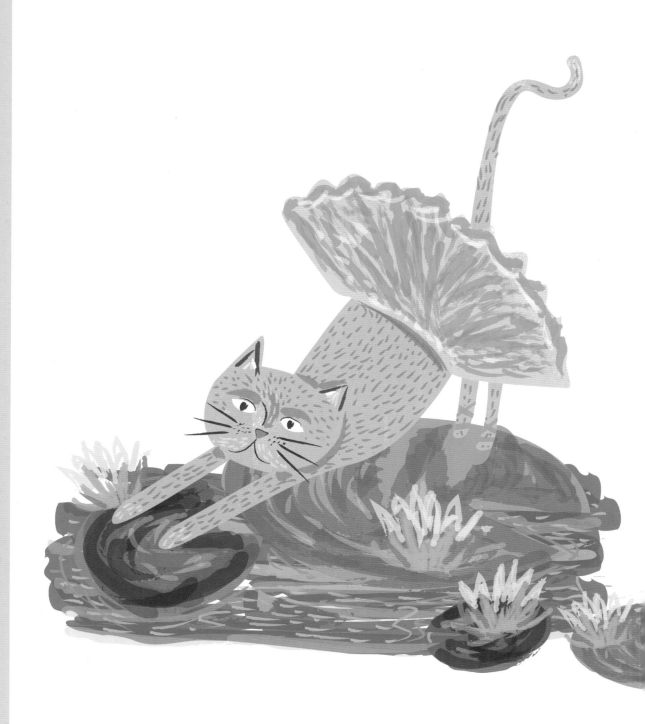

IMPRESSIONISM

Pirouetting around a pond, this feline ballerina is not in the least offended by the derision that heralded the emergence of Impressionism. Cat-astrophic reviews greeted the first offerings of now world-reknowned artists. Seldom does an art movement take its name from an intended insult, but Impressionism is one.

Artists, such as Pierre-Auguste Renoir and Edgar Degas, liked to paint outside, '*en plein air*.' They used distinct brushstrokes to evoke sun, shadow and the fleeting effects of changing light. They experimented with colour combinations, pairing complementary colours – blue/orange, red/green and violet/yellow – to intensify them. While tradition held that warm colours advance and cool ones recede, the Impressionists placed them beside each other rather than using them to separate foreground and background. Once scorned, their radical vision created some of the best-loved paintings today.

> 'The effect of sincerity is to give one's work the character of a protest. The painter, being concerned only with conveying his impression, simply seeks to be himself and no one else.'
> Claude Monet

THE NAKED FORM

Pierre-Auguste Renoir's nudes were both controversial and among his most popular works. He used muted, subtle tones to capture nuances of light and shadow.

WATER

Impressionists were interested in how people 'see' – taking in a scene as a whole rather than as separate elements. Many of Claude Monet's paintings featured water, and he tried to capture the experience of 'seeing' by depicting light and movement.

DEGAS DANCERS

In his thirties Edgar Degas became obsessed with the ballet dancers of the Paris Opéra. For more than 40 years he drew and painted them at the Palais Garnier, using pencils, chalk, pastels and oils. Many of his works have unconventional compositions, often influenced by the new art of photography.

MONET WATER LILIES

Monet painted hundreds of pictures of water lilies in his lifetime. Like a true Impressionist, he was concerned with capturing them at different times of day, in different types of light and conveying different moods.

How to spot an Impressionist painting:

- Loose, broken brushwork
- Pure, bright colours
- Lack of clear boundaries between different elements
- An interest in weather effects
- Emphasis on natural light

'To my mind, a picture should be something pleasant, cheerful, and pretty, yes pretty! There are too many unpleasant things in life as it is without creating still more of them.'
Pierre-Auguste Renoir

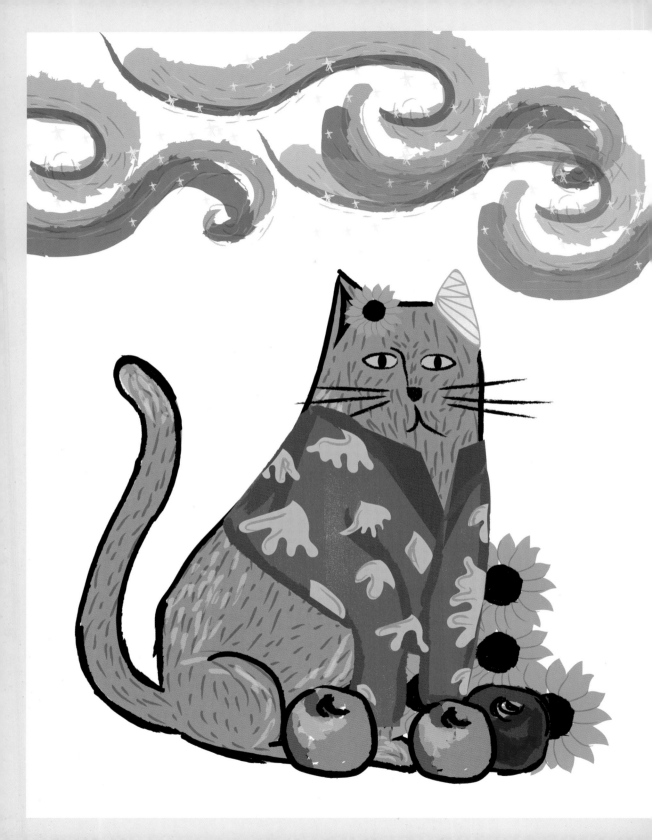

POST-IMPRESSIONISM

Cats are known for testing boundaries and much like the Post-Impressionists, this dapper chap isn't afraid to ruffle a few feathers. The paint was scarcely dry on Impressionist paintings before some artists wanted more emphasis on subject matter and started experimenting with a new style. These trailblazers chose not to look to the past for inspiration, but instead to create new forms of artistic expression. Thus, a move towards abstraction began.

As different in style as cat and dog, the main artists grouped under the name of Post-Impressionists were Paul Cézanne, Paul Gauguin and Vincent van Gogh. Despite their stylistic differences, what they did share was a belief that art should express feelings rather than portray a subject. Cézanne and Van Gogh both painted nature, but while Cézanne combined geometric forms with the Impressionist concern for light and colour, Van Gogh used swirling brushstrokes to create a feeling of depth and movement – much like our adventurous feline friends, his paintings appear to be in a state of constant motion.

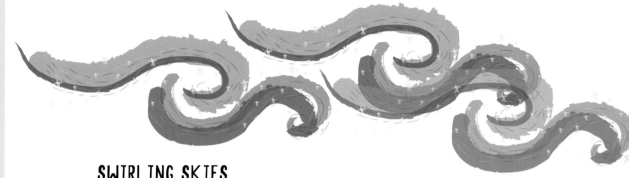

SWIRLING SKIES

A technique called 'impasto', where paint is layered thickly to give a three-dimensional effect, was used to great effect in Vincent van Gogh's *Starry Night*, giving it a feeling of depth and movement. The gentle, mystical mood of the work was inspired by Van Gogh's desire to explore the connection between his intense emotions and reality.

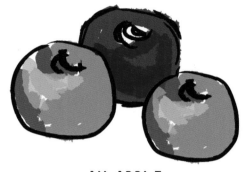

AN APPLE FOR THE ARTIST

These apples show the unusual perspective Paul Cézanne employed to give his paintings a sculptural feel. This innovative approach made him hugely influential to the Cubists, who took this style of painting and exaggerated it.

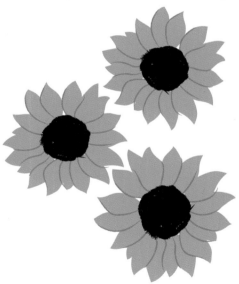

SUNFLOWERS

Post-Impressionists were more concerned with how a picture captured mood and atmosphere than how realistic it looked. Van Gogh's vibrant sunflowers radiate the happiness he felt when painting them.

'My great longing is to learn to make those very incorrectnesses, those deviations, remodellings, changes of reality, so that they may become, yes, untruth if you like — but more true than the literal truth.'
Vincent van Gogh

TOTALLY TROPICAL

Paul Gauguin used a lot of mysterious, dream-like scenes in tropical settings in his work. Although Gauguin tried to encourage Van Gogh to incorporate imaginary elements, his interest was in the ordinary, natural world.

BANDAGED EAR

Van Gogh, famous for his self-portraits, is well-known for supposedly cutting off his ear after an argument with Gauguin. One of his most recognizable paintings, *Self-Portrait with Bandaged Ear*, shows him soon afterwards.

'I shut my eyes in order to see.'
Paul Gauguin

DIFFERENT STROKES

Despite Post-Impressionists moving away from realism, they were still extremely technically skilled and saw mark-making as the foundation of their art. Van Gogh's sketches, made in pencil and charcoal, are so stylized that they are instantly recognizable as his work.

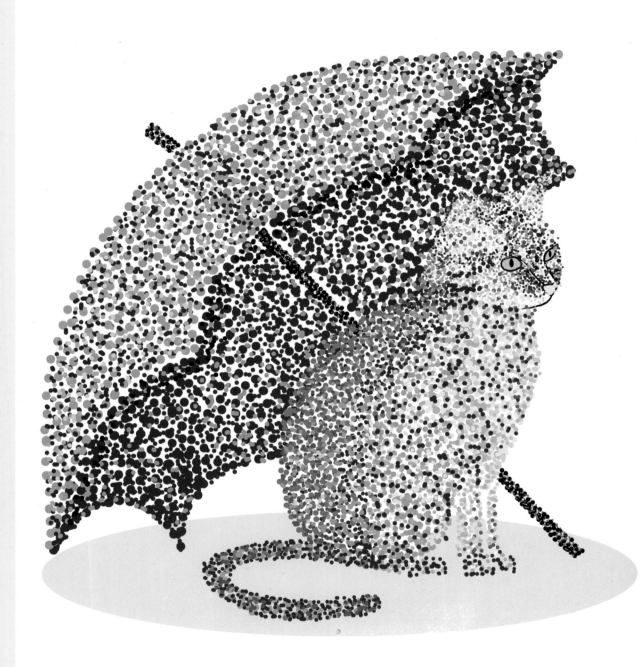

POINTILLISM

Heavily influenced by Impressionist style, artists Paul Signac and Georges Seurat went dotty for a new painting technique that involved meticulously applying tiny spots of pure colour, very close together. The idea was to create a sort of optical illusion – from a distance the dots seemed to fuse together, becoming solid colours.

As usual, art critics sneered at this bold new approach, but this colourful cat had the last laugh as the Pointillist style became hugely influential into the 20th century, and is used by artists to this day.

Pointillism reflected innovative thinking by scientists, who explored how the eyes and brain react to colour, and by the artists who took that knowledge and applied it to canvas. In the shimmering surface of this Pointillist cat, art meets science to triumphant effect.

FEELING SHADY

In one of his most famous works, *A Sunday Afternoon on the Island of La Grande Jatte*, Georges Seurat shows his subjects in formal poses, depicting women walking demurely along a riverbank holding parasols. This could have been intended to draw attention to the repressed nature of upper-class people as he saw them.

NOW YOU SEE IT

A simple experiment can demonstrate how the science of colour works. Try looking at the same patch of blue against different colours – try orange and green – and notice how the blue looks different depending on which colour it's next to.

'The inability of some critics to connect the dots doesn't make Pointillism pointless.'
Georges Seurat

DOTS AND SPOTS

It was the Impressionists who started the trend of applying colour in separate, clearly defined strokes, but the Pointillists took it one step further by developing a technique that made the process much more intricate and precise.

FROM POINTILLISM TO FAUVISM

Pointillism had a huge influence on the Fauvists, who looked to their choice of bold, distinct colours for inspiration.

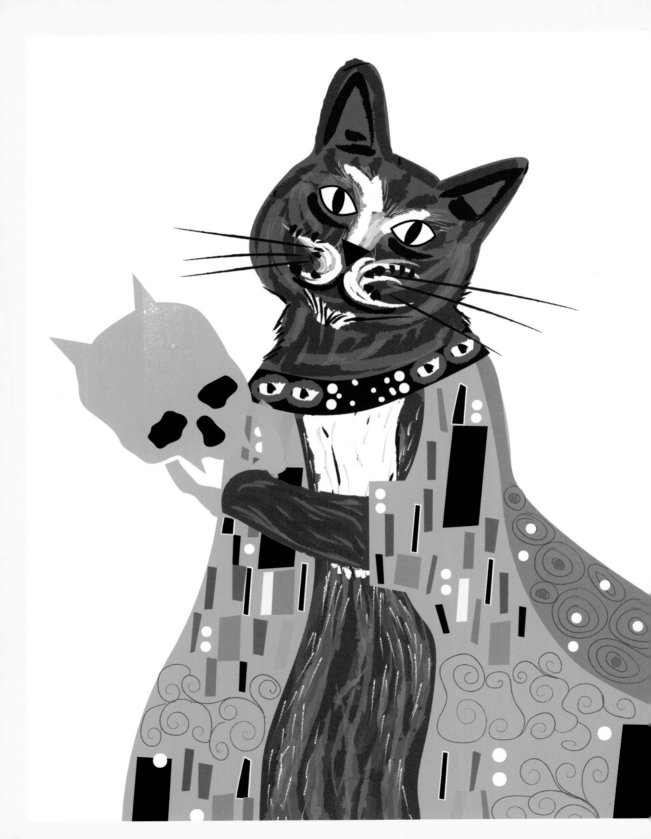

SYMBOLISM

There's no mistaking the fact that this enrobed cat thinks itself a little more high-brow than the average moggy. In fact, it would be the first to explain that the term 'Symbolist' was originally applied to a French literary movement, which explored human emotions through dream-like imagery and mythical themes.

It wasn't long before this approach appealed to artists, too, and the movement spread beyond France, attracting artists all over Europe. It seemed that sex, fear, desire, spirituality, anguish and death held limitless appeal as subjects.

Symbolist artists had no interest in portraying the natural world, preferring to prompt strong emotions in the viewer by their use of unusual colour and composition. Leading figures, such as Edvard Munch and Gustav Klimt, shocked the public with their evocative images, a world away from the light and colour of Impressionism – as this deep-thinking kitty would surely attest.

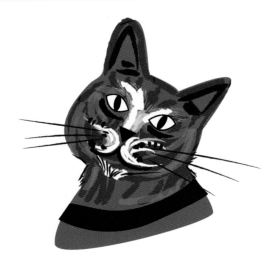

ROUGH WITH THE SMOOTH

The rough, textural application of paint
in some Symbolist works lends a feeling
of rawness, reflecting the Symbolists' aim
to strip the human psyche down to its
most base and shocking elements.

KLIMT PATTERN

Klimt's use of texture and pattern may not
seem unusual from a modern perspective, but at
the time it raised eyebrows among artists and
critics alike. Borrowing from ancient Egyptian and
Byzantine art, his work fused the traditional with
the modern, the abstract with the realistic.

ENSOR MASK

Belgian painter James Ensor used different styles
of masks in his work, creating imagery intended
to show how easily a normal subject could
be disguised and transformed into something
disturbing. He used the masks to suggest the
true character of the subject – which makes
this Symbolist cat very sinister indeed.

*'The colours live a remarkable
life of their own once they have
been applied to the canvas.'*
Edvard Munch

'Whoever wants to know something about me — as an artist which alone is significant — they should look attentively at my pictures and there seek to recognize what I am and what I want.'
Gustav Klimt

FLOWING LINES

Gustav Klimt was notable for his use of smooth, sensuous lines and flowing shapes, combining this with paintings of realistic figures. He created a stir because people felt his work to be too erotic and shocking for contemporary viewers.

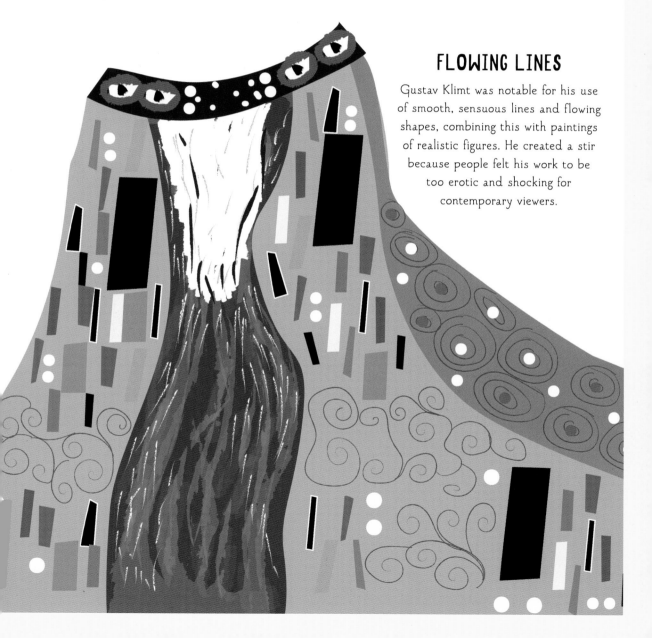

FAUVISM

Don't be deceived – this friendly-looking feline represents the movement and artists that came to be known as 'les fauves', which means 'wild beasts'. They favoured simplified forms and bold, unnatural colours, applied with the energy of a cat chasing its tail. Their work astounded visitors of the 1905 Salon d'Automne exhibition in Paris, including critic Louis Vauxcelles, who gave the movement its name.

The name stuck and the movement grew. Artists André Derain and Henri Matisse spent the summer together painting on France's Mediterranean coast. They explored recent scientific colour theories, mostly relating to complementary colours. Soon other artists adopted the Fauvist style, but for the most part it was a temporary phase (even the sweetest-natured cat enjoys the odd stint as a wild beast). Matisse remained a Fauvist, though, and his work using bright colours and collage elements can be seen in the world's greatest museums.

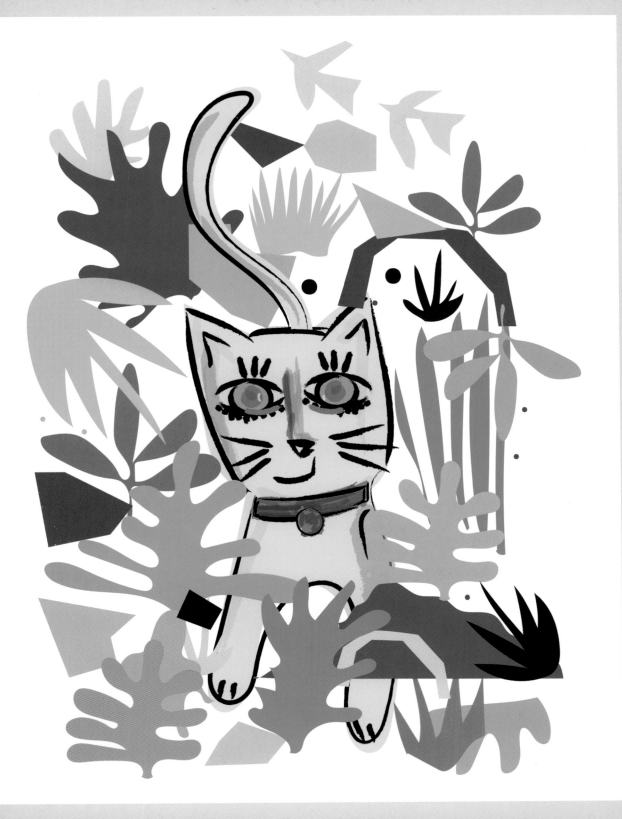

CUT-OUT COLLAGE

Henri Matisse started making his cut-out, collage-style pieces when he was unwell and unable to paint. He used the principles of Fauvism, such as the bright colours and bold, simple shapes, and translated them into this unusual medium.

VAN DONGEN EYES

Kees van Dongen was one of the most popular artists of the Fauvist movement, famous for his bold and colourful portraits. He painted glamorous-looking women, emphasizing their large, oval, heavily made-up eyes.

UNNATURAL COLOURS

The Fauves aimed to separate the use of colour from the subjects that were represented, which distinguished them from more traditional art movements. Matisse's painting *The Green Line*, which showed his wife with a central streak of green paint down her face, was considered by some to be offensive.

The pure, bright colours used by Fauvist artists were not intended to represent real life.

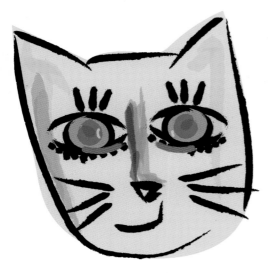

LOOSE STROKES

André Derain used broken brushstrokes, strong outlines and vibrant colours to evoke a feeling of pace and spontaneity.

'We become intoxicated with colour, with words that speak of colour, and with the sun that makes colours brighter.'
André Derain

PURE COLLAR

The way that Matisse applied paint, with thick, broad strokes, seemed crude to many. In the style of this collar, he often used 'pure colour', unmixed paint straight from the tube, because he had to work quickly in order to capture his mood.

THE BIRDS

Matisse's cut-outs often featured birds – in fact his great work *Oceania, the Sky* developed from a cut-out in the shape of a swallow. It could be said that the light, space and freedom associated with these winged creatures mirror the ethos of Fauvism.

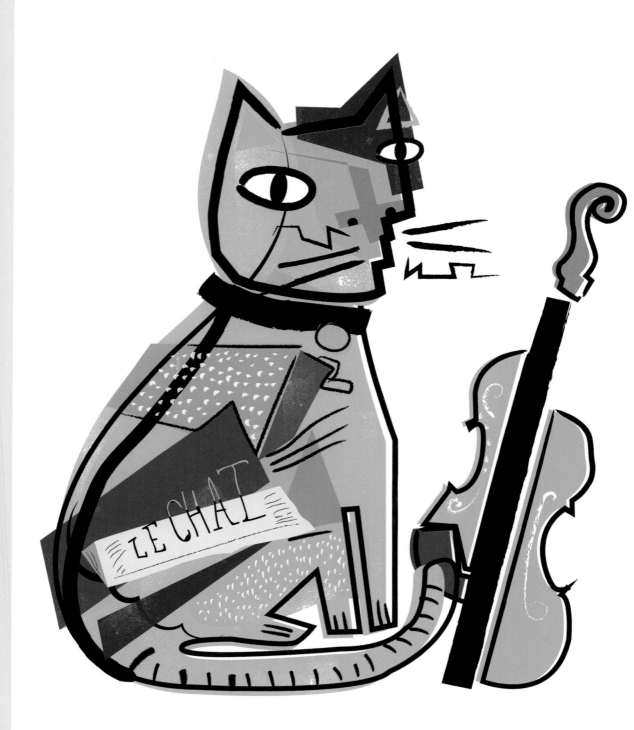

CUBISM

Scandalous! When Cubism first appeared at the beginning of the 20th century it caused uproar among the public and even in the art world. Instead of trying to convey depth by using perspective, tone and colour, Cubist artists showed their subject from different angles at the same time, using geometric shapes in unexpected combinations. The most famous of the Cubists was Pablo Picasso, an ardent cat-lover, whose work often depicted feline forms with features at unusual angles.

There are two main types of Cubism. Analytical Cubism used a lot of black, grey and ochre which gave a stark, severe feel. This was followed by Synthetic Cubism, which used brighter colours, simpler shapes and added elements of collage.

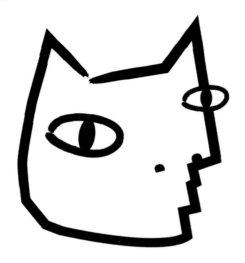

FRAGMENTS OF A WHOLE

Fernand Léger embraced the Cubist idea of breaking subjects down into geometric shapes. Unlike many Cubists, though, he still tried to give the illusion of three-dimensionality. He added areas of texture alongside flat colour to give a sense of depth and contrast.

A DIFFERENT ANGLE

The Cubists used flat geometric shapes to represent the different sides of objects. Their aim was to show them in their entirety, rather than just what was immediately visible. They thought that they could give the viewer a more accurate understanding of an object by showing it from different angles.

PICASSO NOSE

Pablo Picasso often painted people with straight or square noses, lending them an air of unemotional indifference. This was part of a rejection of traditional skills taught in art academies at the time, which he perceived as elitist.

The term 'Cubism' was initially intended as an insult to these strange, graphic works, and was coined by art critic Louis Vauxcelles, when he complained that a painting by Georges Braque was 'full of little cubes'.

'What is called a sincere work is one that is endowed with enough strength to give reality to an illusion.'
Max Jacob

GRIS COLLAGE

Juan Gris used large pieces of newspaper and advertisements as collage elements alongside traditional materials. These remnants of ordinary life were intended to raise popular culture to the status of high art and paved the way for movements such as Pop Art to do the same.

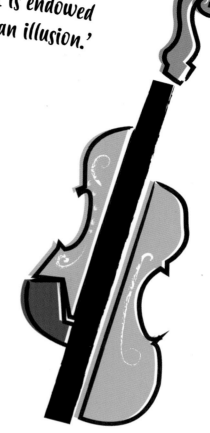

ANGULAR WHISKERS

Right angles and straight lines were used wherever possible to give artwork a Cubist feel. Everyday objects gained an 'otherworldly' quality in this way. Although Picasso and Georges Braque were the first to favour this approach, it was later adopted by sculptors and architects in their three-dimensional works.

LET THE MUSIC PLAY

Musical instruments were popular motifs in Cubist art, with string instruments, such as violins and guitars, the most commonly used. Some people think this is because the shapes of the instruments mimic the curves of the human body.

COLOURS

The brighter palette of Synthetic Cubism makes a pair of perfectly colour-popping ears for a Cubist cat.

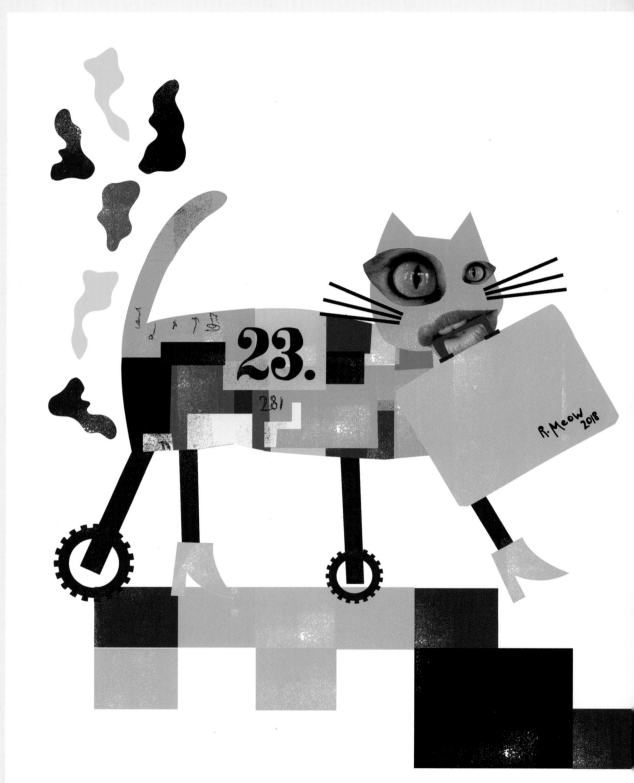

DADAISM

This quirky cat is a prime example of the experimental nature of Dadaism. A movement founded in Europe in reaction to the horrors of the First World War, artists such as Francis Picabia, Hannah Höch and Kurt Schwitters set out to shock the middle classes – easily done in those days! Stylistically, anything was up for grabs and the Dadaists often expressed themselves in nonsensical and irrational ways. This might explain why this hybrid creature is half high-heeled glamourpuss, half heavy machinery.

The Dada art style varied from one city and country to another – from political photomontage in Berlin, grotesque and erotic collage in Cologne, to found objects in New York. In Paris, Marcel Duchamp created 'readymades', famously buying a urinal from a bathroom supplier and calling it *Fountain*. The idea was that an artist didn't need to make an object for it to be art but instead could simply choose it. Most of all, Dada meant anarchy – something most cats can relate to.

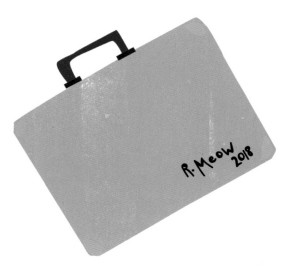

MACHINE PARTS

Known as 'Papa Dada', Francis Picabia used industrial elements to celebrate the technological advances that he believed were vital to the development of American culture. He produced a series of 'mechanomorphic' works, which looked like playful versions of technical drawings.

DUCHAMP SUITCASE

One of the first Dadaists, Marcel Duchamp's 'anti-art' mentality defined his work. He used everyday, mass-produced items such as a suitcase as the basis for his pieces, in order to express his distaste for materialistic attitudes towards art and culture.

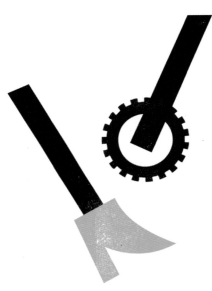

'It's inspiration that counts, not the drill.'
Hugo Ball

23.

SCHWITTERS COLLAGE

Kurt Schwitters created collages that challenged the very definition of 'art' and artist's materials, using discarded papers and other found objects. He even encouraged artists to add to his work, turning the experience of his work into something that others could participate in, rather than simply observe.

No-one is totally sure where the term 'Dada' came from, but a popular story is that the artist Richard Huelsenbeck chose the word at random by plunging a knife into a French-German dictionary.

DON'T BE A SQUARE

Hans Arp pioneered a technique that crossed collage with abstraction, tearing squares from paper, dropping them onto separate sheets and sticking them wherever they fell. The tidiness and regularity of his finished pictures suggests he may have given them a helping hand, though.

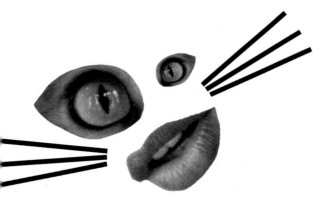

PHOTOMONTAGE

Hannah Höch was a prominent female artist in the Dada movement. Like others, she used photomontage to create surreal and disjointed pieces that questioned society's expectations of women and beauty.

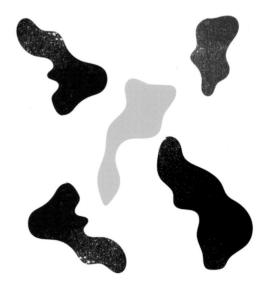

ARP SPLODGES

Much of Arp's work used organic, irregular shapes, like these colourful floating blobs. The seemingly random placement belies his obsession with structural balance, and brings a trademark touch of humour to a Dadaist cat.

DE STIJL

Me-OW! It's hard to imagine the hard lines and sharp corners of this cat settling cosily on a lap. However, the De Stijl-style artwork is instantly recognizable with its graphic, geometric shapes and bright colours. Founded in 1917 by Piet Mondrian and Theo van Doesburg, De Stijl became a hugely influential movement in art, architecture and design, aiming to do away with the bells and whistles that came with trying to portray a subject realistically and instead stripping art back to basics. Mondrian gave the name 'neo-plasticism' to this severe art style that was based on horizontal and vertical lines and a palette of primary colours with black, white and grey.

The simplicity of this cat belies the wider intention of the De Stijl artists – to create a new and better form of society with a simpler, more spiritual quality. Sadly, if inevitably, the group broke up when they realized that their Utopian ideals weren't attainable. Of course, there's not normally much of a straight line about a cat, except the one that it takes to its food bowl.

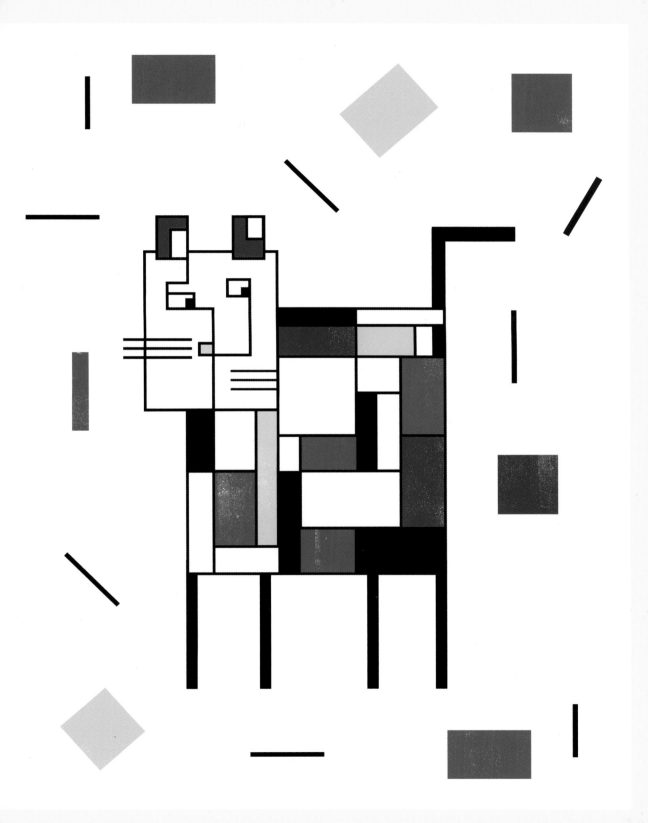

So determined was Piet Mondrian to stick to the De Stijl principal of using only straight lines, that when Theo van Doesburg began to incorporate diagonal lines, Mondrian withdrew from the movement in disgust.

Using a limited palette of red, yellow and blue, as well as black and white, followed the De Stijl idea of reducing art to the very basics of form and colour.

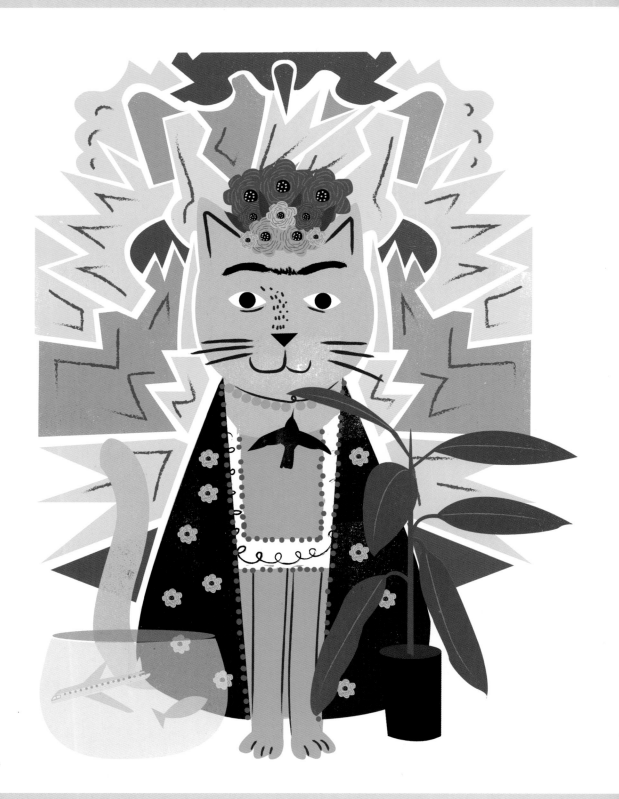

MAGIC REALISM

This stylish kitten is inspired by Frida Kahlo's iconic self-portraits and, like the best Magic Realism, some fantasy elements have been included in her colourful depiction. It's not surprising that Kahlo has been an inspiration — she is one of the most famous artists who worked in the Magic Realist style, producing pieces that combined stark realism with fantasy elements, to represent a symbolic reality that she felt existed where the ordinary and extraordinary worlds meet.

Other artists, such as Franz Radziwill and Alberto Savinio, used odd juxtapositions of objects, distortions of space, allegory and symbolism. Some of their work could be described as surreal, but the Magic Realist artists made a point of distinguishing themselves from the Surrealists by focusing on real objects rather than the unconscious mind; a giant Magic Realist mouse wouldn't be only in this cat's dreams.

WEIRD BUT WONDERFUL RADZIWILL

Franz Radziwill was the master of taking a normal scene and adding disturbing elements to create an eerie feel. One of his most famous works, *Beach of Dangast with Flying Boat*, depicts an everyday beach scene with the unusual addition of a propellerless, boat-shaped aeroplane. In homage, this Magic Realist cat will get a shock if it decides to go fishing in the Radziwill-inspired fishbowl.

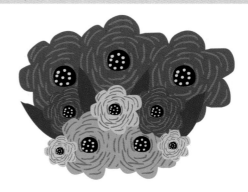

FLORAL HEADPIECE

Frida Kahlo's floral headpieces are instantly recognizable from her many self-portraits. She used flowers as a way to celebrate her Mexican heritage and as a symbol of fertility, which was a preoccupation of Kahlo's and the subject of many of her paintings.

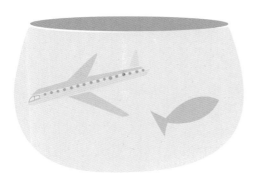

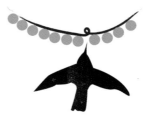

SAVINIO BACKGROUND

Alberto Savinio combined bright, geometric shapes with dark, brooding, realistic scenes, bridging the gap between realism and abstraction. This type of juxtaposition was often used in Magic Realist work to draw attention to the strangeness of real-life experiences, as opposed to dwelling on the mysteries of the unconscious mind, as the Surrealists did.

WATCH THE BIRDY

In Mexican culture the bird is a symbol of good luck, and it appears in Kahlo's work to suggest a positive outlook despite the unhappiness in her life.

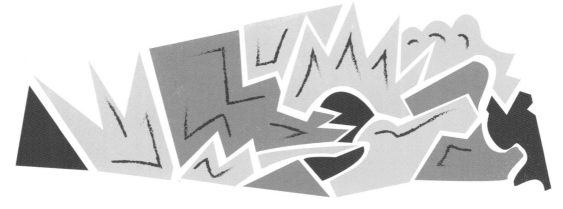

KANOLDT HOUSE PLANT

In line with the highly realistic style used in many Magic Realism works, one of Alexander Kanoldt's favourite subjects was the ordinary potted plant. This most simple of subjects was given a detached, otherwordly feel by his use of graphic lines and muted colours.

KAHLO COSTUME

Renowned for her flamboyant dress sense, Kahlo often appears in her self-portraits in traditional Mexican clothing. While her portraits often explore the physical pain caused by her disabilities, due to a childhood illness and a near-fatal accident in her teens, some think her costumes point to a wider cultural significance beyond her pain.

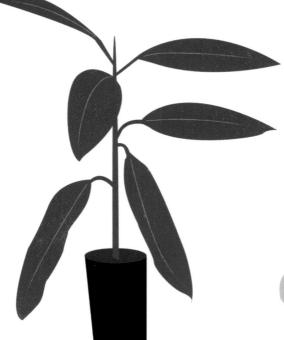

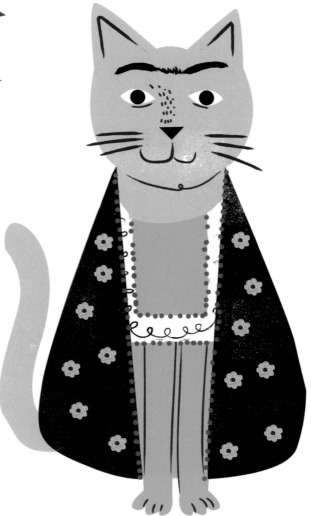

Magic Realist artists aimed to combine the true-to-life with the imaginary. Having much in common with Surrealism, some artists, such as Frida Kahlo, could be said to straddle both movements.

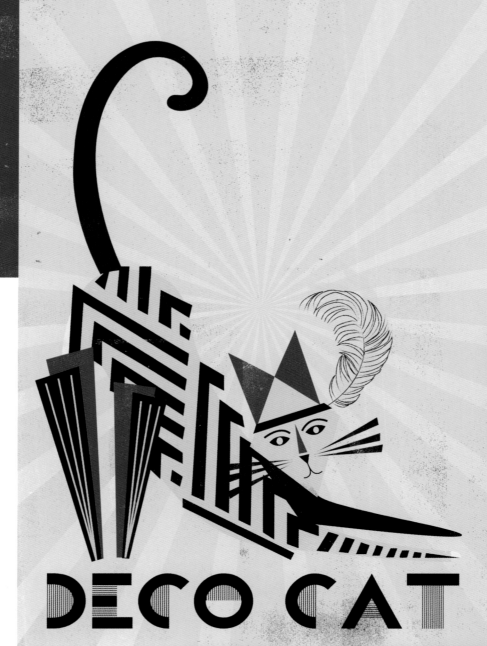

DECO CAT

ART DECO

A more fashionable and trendsetting cat is difficult to imagine.
The Art Deco style burst into being in the 1920s when optimism and
creative energy replaced the traumas of the First World War. Originally
called *Style Moderne*, its influence was to blaze a trail across many
disciplines, including fashion and architecture. Its own influences were
equally wide-ranging – they included folk art, Cubism, Fauvism and
art from India and the Far East. The discovery of Tutankhamun's
tomb in 1922 prompted a huge public interest in ancient Egypt
and added another exotic element to the already eclectic mix.

This sleekly elegant feline is typically Art Deco, with its graceful
geometric forms and inherent air of wealth and luxury. However, while
seriously stylish, it was these elements that caused the movement to fall
from grace during the Depression of the 1930s. Nevertheless, Art Deco
style is still much-loved in the modern world for its sheer glamour.

From clocks to cars, movie posters to skyscrapers,
Art Deco artists aimed to bring a touch of glamour
to even the most functional of designs.

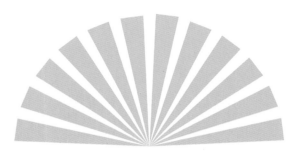

LET IT SHINE

Sun rays were a perennial motif in Art Deco works. Radiating from a central point and frequently used as a background pattern, this common device was unusual compared to other modern art styles, which made a feature of sparse and simple decoration.

FORM AND FUNCTION

In Art Deco, functionality, as well as form, was a major concern. Artists wanted to make mass-produced objects as attractive as possible and bring beauty to the everyday. In this vein, a common moggy has been given an elegant makeover here.

GEOMETRIC SHAPES

Art Deco works were generally made up of streamlined, geometric shapes and were designed to be attractive, rather than intellectually challenging. This was in contrast to other art styles of the period that were more avant-garde and aimed to challenge the viewer's perceptions of art.

FEATHER HEADBAND

The Art Deco style originated in Paris. This glamourpuss is sporting a feathered, flapper-style headband, in homage to the popular style of the era.

ZEBRA-STRIPE WHISKERS

Art Deco artists often used animal prints, such as tiger or zebra stripes, to represent wealth and extravagance.

POSTER ART

A.M. Cassandre was famous for his bold, graphic style, most notably his travel posters. His work, with its strong, graphic typography and Surrealist and Cubist influences came to be synonymous with the art of the era. He is still considered by many to be the greatest ever poster artist.

SURREALISM

A cat in a bowler hat wouldn't raise an eyebrow among Surrealist artists. Even the addition of a decorative mermaid tail or a pair of claws would fail to shock.

At first glance, a lot of Surrealist art looks like random objects, merged indiscriminately (lobster telephone, anyone?), but there is a fascinating philosophy behind this apparent disregard for convention. Artists such as Salvador Dalí, René Magritte, Max Ernst and Joan Miró took recognizable everyday objects and rendered them in unfamiliar ways. They aimed to jolt viewers out of their familiar assumptions and force them to consider what might be going on in their unconscious minds.

Surrealist artists found magic in the strange beauty of the unexpected and otherworldly. Nature provided their most frequent inspiration. Dalí's work often included ants and eggs, and Ernst even painted his alter ego in the form of a bird.

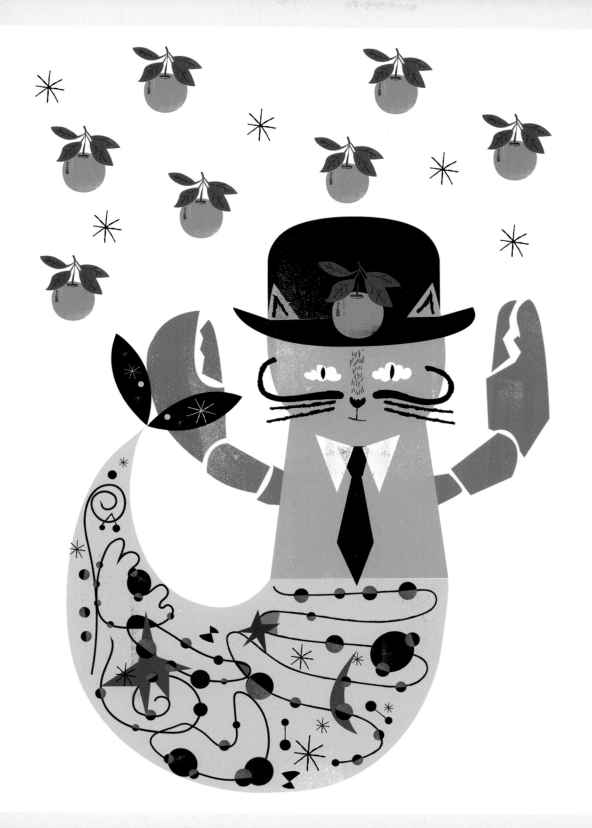

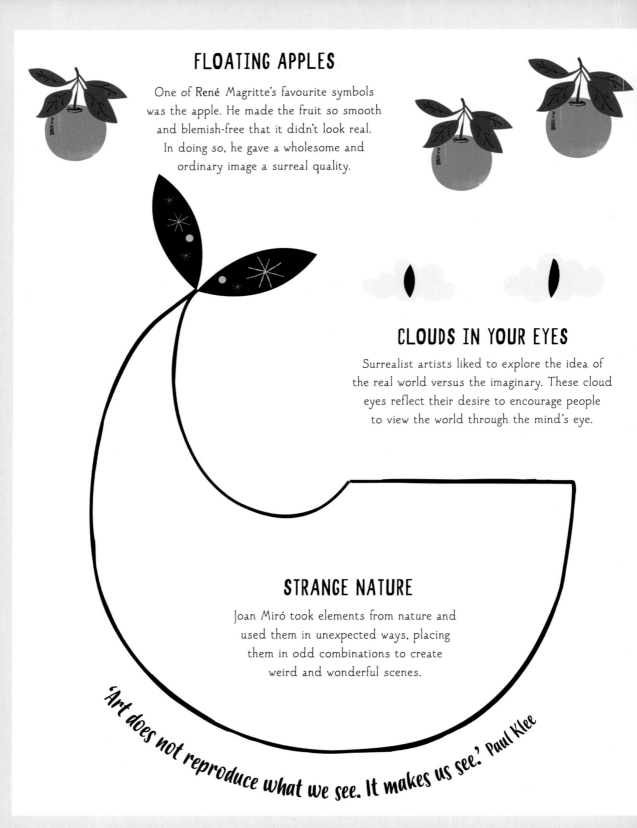

FLOATING APPLES

One of René Magritte's favourite symbols
was the apple. He made the fruit so smooth
and blemish-free that it didn't look real.
In doing so, he gave a wholesome and
ordinary image a surreal quality.

CLOUDS IN YOUR EYES

Surrealist artists liked to explore the idea of
the real world versus the imaginary. These cloud
eyes reflect their desire to encourage people
to view the world through the mind's eye.

STRANGE NATURE

Joan Miró took elements from nature and
used them in unexpected ways, placing
them in odd combinations to create
weird and wonderful scenes.

'Art does not reproduce what we see. It makes us see.' Paul Klee

'Biomorphism' is a word that came into use in the 1930s, and describes an inanimate object that takes on the qualities of a living thing.

PAW OR CLAW?

Salvador Dalí often featured lobsters in his work, famously creating a telephone with a lobster claw instead of a handset.

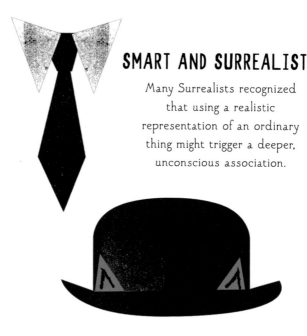

SMART AND SURREALIST

Many Surrealists recognized that using a realistic representation of an ordinary thing might trigger a deeper, unconscious association.

DALI FACE

Surrealism relies on the contrast created by combining the realistic and the fantastical. This feline face, for example, wears Dalí's curly moustache.

MAGRITTE BOWLER HAT

One of the most recognizable emblems of the Surrealist movement is the bowler hat – Magritte painted dozens of pictures featuring them. Many think they represent bourgeois life, acting as a contrast with the more fantastical elements of his work.

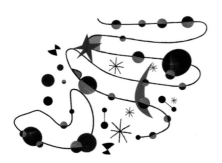

MIRO MERMAID TAIL

Miró often looked to the sky for inspiration and constellations were one of his favourite subjects.

'Surrealism is destructive, but it destroys only what it considers to be shackles limiting our vision.'
Salvador Dalí

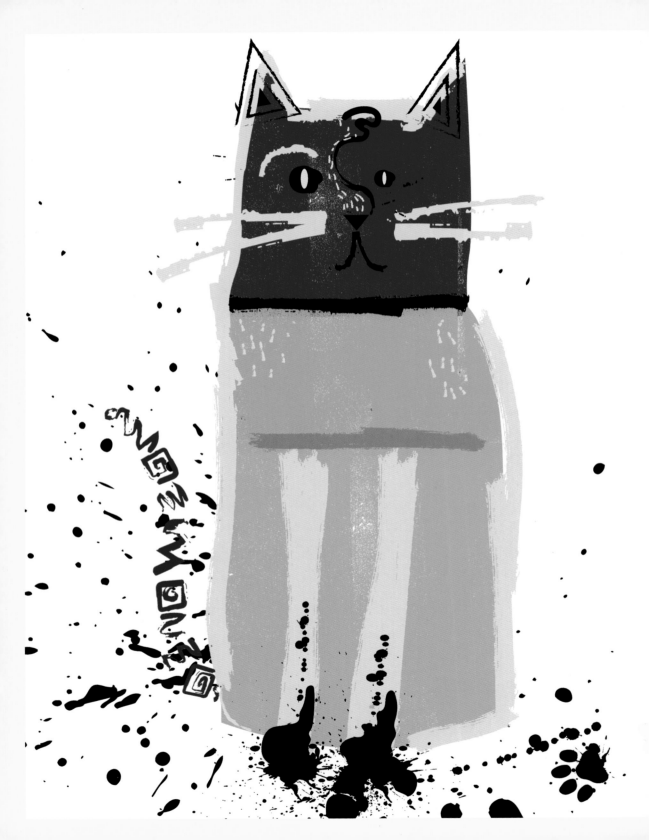

ABSTRACT EXPRESSIONISM

Just as a typical cat hates to be confined, so the Abstract Expressionists strived to imbue in their work a sense of freedom. It is perhaps the art movement most likely to have inspired feelings of 'I could have done that' in some viewers of the time, yet the most famous Abstract Expressionists were experts in drawing, composition and colour. They simply chose the radical approach of expressing their ideas without painting recognizable objects.

With his colour-block pattern and painterly paw prints, this mixed-up moggy is representing the two distinct categories of Abstract Expressionism at once. The key difference between them is the type of emotions they convey. The 'action painters', who included Jackson Pollock, Franz Kline and Willem de Kooning, were passionate and intense, using huge canvases and a dynamic style. Their art is in contrast to the subtle, meditative effects created by 'colour field' painters Mark Rothko and Barnett Newman.

JACK THE DRIPPER

Jackson Pollock developed the now-famous technique of 'drip painting' – pouring, dripping and throwing paint onto his canvases.

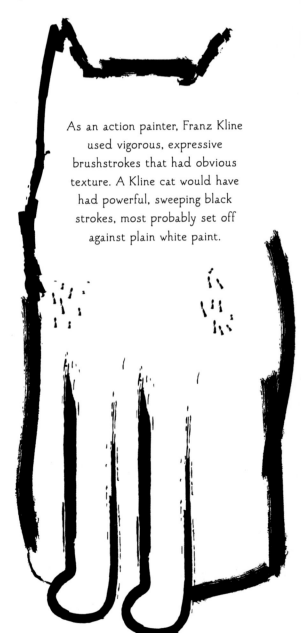

As an action painter, Franz Kline used vigorous, expressive brushstrokes that had obvious texture. A Kline cat would have had powerful, sweeping black strokes, most probably set off against plain white paint.

KANDINSKY CAT-FACE

Wassily Kandinsky was a Russian painter who was a huge influence on the movement. Pre-dating the Abstract Expressionists, he is often credited with creating the first purely abstract works.

COLOUR-BLOCK FUR

Mark Rothko's trademark was using vertically aligned coloured shapes set against flat-coloured backgrounds. He thought these had the power to represent basic human emotions, such as tragedy, ecstasy and doom.

WHISKERS

Willem de Kooning was a master of 'gestural abstraction' – taking apart, distorting and reassembling the elements of figures using bold, expansive brushstrokes.

POLLOCK PAW PRINTS

Pollock worked spontaneously, walking and dancing across his canvases to channel his subconscious impulses. His footprints can be seen in some paintings, so an Abstract Expressionist cat might leave its own paw marks in paint.

DE KOONING HAIR, DON'T CARE

De Kooning often left his paintings with an unfinished feel, as if the brushstrokes were still in motion across the canvas.

EARS

Throughout her career, American artist Lee Krasner changed her style several times. After time spent focusing on small, geometric shapes, she went on to produce large, expressive canvases.

KRASNER TAIL

At times Krasner painted in a state of 'controlled chaos', using defined shapes on a much smaller scale than her contemporaries. Her geometric paintings demonstrate the expressive power of small, intricate lines, especially when placed next to bigger, bolder pieces by other artists.

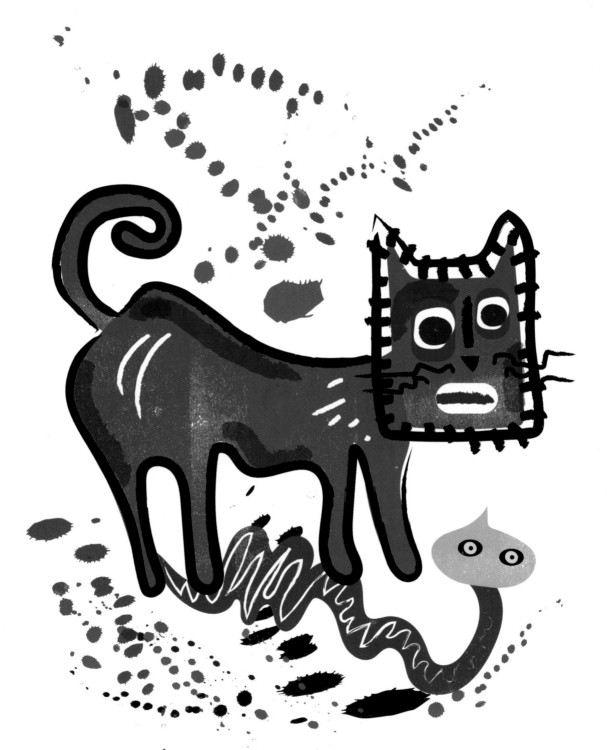

CoBrA

It may look naïve and child-like, but this revolutionary cat has one thing on its mind – changing the way people think about art. It's in good company, too. The CoBrA group formed at the end of 1948 was founded by artists Cornelis van Beverloo (Corneille), Karel Appel, Asger Jorn and Constant Nieuwenhuys (Constant). Choosing not to offer any detailed doctrine in their manifestos, they instead focused on a need to 'discover their desires'.

The group subscribed to the Surrealist theory of 'automatism', where the artists allow unconscious impulses to direct the painting or drawing process. Very much a group affair, the artists were Marxists and desired to break down the barriers that isolate individuals, collaborating on books and prints. In the summer of 1949 they painted murals together on all the walls and ceilings of a house near Copenhagen (that explains the paint splatters). This CoBrA cat would soon be left to its own devices, though; the group disbanded in 1951 and its members followed their own artistic paths.

EXPRESSIVE OUTLINE

Loose and expressive brushstrokes were the trademark of CoBrA artists – there is a freedom to their painting that was consciously adopted, inspired by the way that children created art.

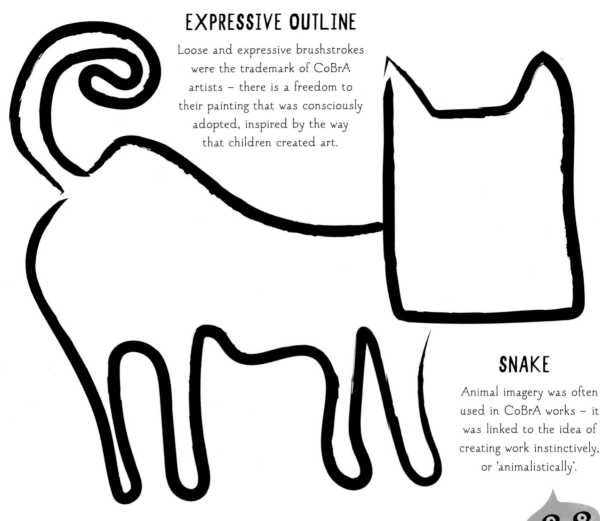

SNAKE

Animal imagery was often used in CoBrA works – it was linked to the idea of creating work instinctively, or 'animalistically'.

CORNEILLE WHISKERS

Corneille made use of playful marks in his work. Describing himself as 'a painter of joy', he was in conscious opposition to the horrors of the Second World War that he, along with other CoBrA artists, used his art to counter.

While CoBrA artists had much in common with the Surrealists and the Abstract Expressionists, their work was even more emotionally driven.

The name 'CoBrA' was made by combining the initials of the founders' home cities – Copenhagen, Brussels and Amsterdam.

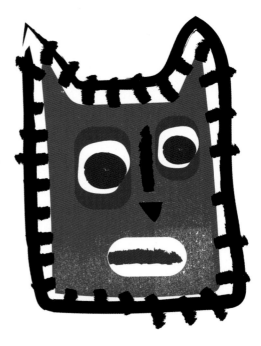

SPLATTERS

CoBrA artists valued bright, spontaneous painting – this, alongside their political motivations, sometimes draws comparisons with the Abstract Expressionists.

TRICOLOUR PALETTE

A palette of red, white and blue was used by Constant in the famous CoBrA painting *After Us, Liberty*. The choice of colours was intended to capture the essence of the French flag and all it stood for.

APPEL FACE

Karel Appel painted childlike faces, intending to reflect the children he saw begging in the streets. His naïve, mask-like faces were in stark contrast to the art that people were used to seeing in museums and galleries at that time. They were a reaction against what he perceived as the overly conservative attitudes of the art world.

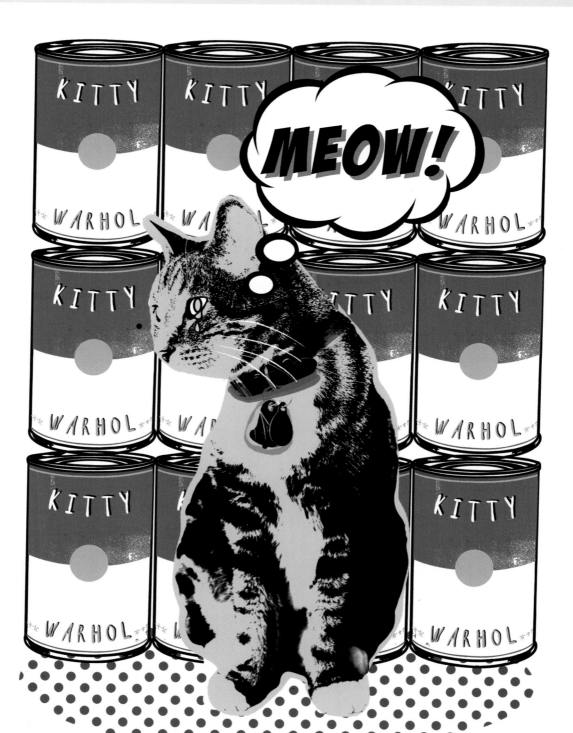

POP ART

This bright, bold and brash cat is showing off the rock 'n' roll attitude that was a hallmark of the rebellious Pop Art movement. It arrived with a 'Bang!' and a 'Wham!' in the 1950s, just as Britain and the USA embraced a manufacturing boom, and many Pop artists took advantage of mechanical techniques, such as screenprinting, to make their images.

The pieces were often based on comic strips and advertisements and include dialogue, logos and exclamations, emphasizing their kitsch appeal. While the irreverence of Pop Art might have shocked the old guard of the fine art world, it gave the public a new and liberating view of what art could be.

These tins, stacked high, might demonstrate a return to representing subjects more realistically, but it seems it's not enough to soothe this sensitive soul. Maybe someone has misplaced the tin opener?

Many people, art critics included, were horrified by the way in which 'low' culture was presented as 'high' art.

POPPING PALETTE

Bold, bright, attention-grabbing colours were favoured by Pop artists. Andy Warhol made use of clashing colours in his silkscreen paintings, repeating the same image numerous times in different, contrasting colours. These pieces represented his comment on mass production and the consumerism of the time.

HAMILTON COLLAGE

Richard Hamilton was a huge influence on the Pop Art movement, particularly in England. He believed that all art was created equal, perceiving all visual works as art in their own right. He frequently used collage elements taken from magazine advertising in his work. In doing so, he paved the way for artists such as Andy Warhol, Roy Lichtenstein and Claes Oldenburg.

THINKING OUT LOUD

Roy Lichtenstein aimed to elevate popular culture to the status of high art. He believed that what was displayed in museums had little relevance to contemporary viewers. Using speech and thought bubbles in his work was a way to give popular, mass-produced images inspired by comic books a place in galleries.

WARHOL SOUP CANS

Pop Art marked a return to a more representational style of art. In one of his most iconic pieces, Warhol made use of advertising imagery, creating screenprinted soup cans to celebrate the difference between graphic, structured form and the looser forms in Abstract Expressionism.

CRYING EYE

Many of Lichtenstein's paintings featured women in apparent distress. Along with the frame-by-frame nature of his work, his pieces gave the impression of capturing a dramatic moment in time and encouraged the viewer to use their imagination to create the rest of the story.

BEN-DAY DOTS

Lichtenstein's comic-book style artwork gets its distinctive look from his use of the 'Ben-Day' dots printing process. The idea was that the viewer's eye would fill in the spaces between the dots, giving the appearance of flat colour.

Pop Art was produced on both sides of the Atlantic, but the two types are seen as distinct. British Pop Art could be taken as a parody of American culture, whereas American Pop Art was a result of the artists' direct experience of that culture.

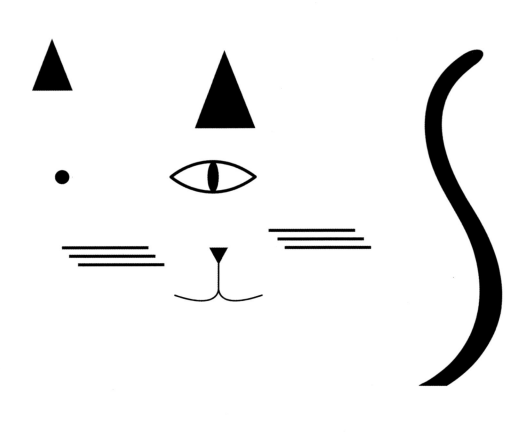

MINIMALISM

There's not a shape or a line to spare on this semi-Minimalist 'masterpuss'. A reaction against the excesses of Abstract Expressionism, Minimalism aimed to represent nothing but itself, instead concentrating on form and the materials the artwork was made of (which means this cat is a bit too recognizable to be truly Minimalist, but when did anyone have any success in getting a cat to follow the rules?)

Minimalism first began to appear towards the end of the 1950s and became prominent in the 1960s and '70s. You'd be hard pushed to find a cute and fluffy kitty amid the three-dimensional sculptures and installations created by artists such as Sol LeWitt and Donald Judd – their sleek and streamlined artworks had more in common with a sophisticated Siamese cat. Often making use of industrial materials, Minimalists emphasized a democratic approach that is far removed from the reverence people might be expected to feel for fine art, or beloved pets.

The Minimalists produced work that
focused on sleek, geometric shapes
that gave an impersonal feel.

Striving for a look that was as pared back as possible, a
lot of Minimalist art was so simplified that it seemed to
have very little content. A simple play on shape, form
and scale make this cat a semi-Minimalist masterpiece.

In a move away from highly charged, emotion-filled art, many Minimalist works employed a heavily industrialized, factory-produced feel.

GRAFFITI

A smiley, happy cat it may be, but there are certainly people who would have liked to have this graffiti scrubbed off if they saw it decorating a public building. Despite this disapproval, the pioneers of street art created an aesthetic that has been hugely influential both on gallery walls and in popular culture. Artists such as Jean-Michel Basquiat, Keith Haring, Futura 2000 and Kenny Scharf have also produced album covers, stage backdrops and clothing; Haring even covered singer Grace Jones's body with graffiti for a stage performance (something this paint-spattered puss can definitely relate to).

There's no denying that the most famous graffiti artists have taken the medium from backstreet mess to mainstream success – a painting by Basquiat was sold for $110.5m in 2017. More generally, however, graffiti remains controversial. In 2008, London's Tate Modern invited six international artists to paint huge murals on its façade as part of a street art exhibition. On the day the exhibition opened, members of London's DPM street art crew were sentenced to prison for their graffiti in the same city.

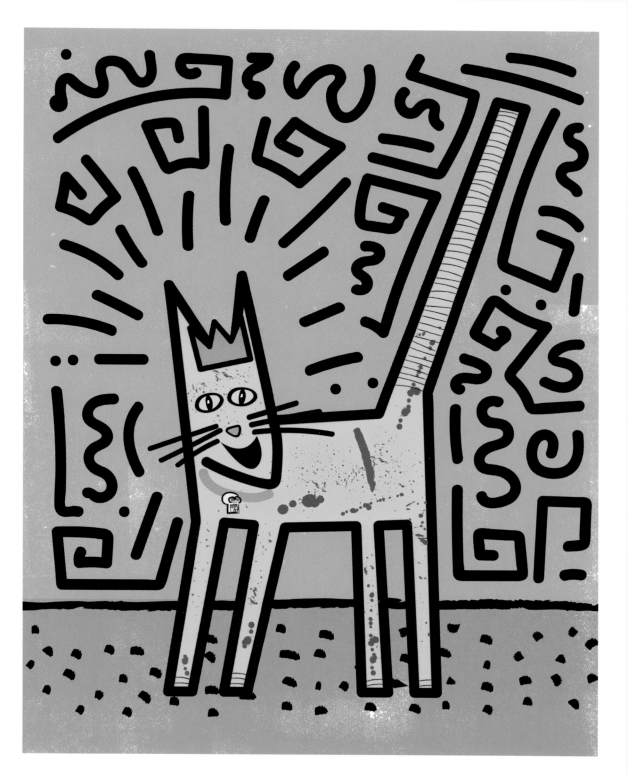

FUTURA'S SHAPES

One of the central figures in Futura's work was Pointman, an alien-like character with an elongated, pointy head.

KING BASQUIAT

The crown was just one of the recurring motifs that featured in Jean-Michel Basquiat's work. He added it mostly to pictures of people he admired, to signal his respect for them, or to represent himself in the work.

The word 'graffiti' comes from the Italian 'graffiato', meaning 'scratched'. This refers to the earliest forms when pieces would be carved into walls rather than painted.

STREETWISE SKULLS

Basquiat used a skull motif instead of painting himself, in a contemporary take on the idea of self-portraiture. He tied it to the idea of the graffiti artist as a lawbreaker, thereby taking ownership of a negative stereotype.

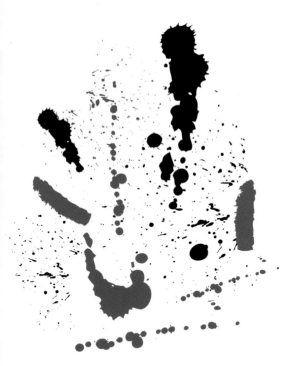

SPLATS AND SPLASHES

Futura helped to define the graffiti movement of the late 1970s by moving it away from lettering and towards a more painterly style. It's clear from his work that he has much in common with the Abstract Expressionists, particularly in his use of loose brushstrokes, paint drips and colourful splatters.

SCHARF FACE

Kenny Scharf used cartoon-style imagery as a high-brow take on 'low' culture.

DOODLE BACKGROUND

Keith Haring used graffiti techniques to make his work feel accessible to everyone; he wanted viewers to be engaged so that he could communicate important messages about social issues. His clean lines and sharp images contrasted with the looser work of his contemporaries.

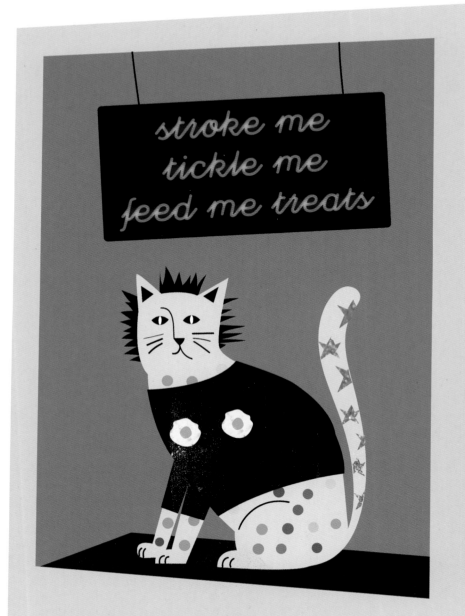

YOUNG
BRITISH ARTISTS

Behold this odd-looking creature and imagine how this edgy art style catapulted a group of art students to international fame and fortune. The Young British Artists first became known when Damien Hirst organized an exhibition called Freeze in an empty industrial building in London. They meant business from the start, even organizing a big corporate sponsor for their catalogue, hoping to 'lap up' the rewards of mainstream success.

This conceptual cat is typical of the way the 'YBAs', as they became known, were prepared to shock the public in pursuit of their art. Just be grateful it has not been sliced in half. The group didn't share any distinctive style apart from a completely open-minded approach to what might constitute art, and a thick-skinned approach to criticism from the press, which mocked their use of found objects and 'low' culture. It seemed that shock and ridicule were like catnip to this media-savvy group, but their gamble paid off and most became highly successful artists who are now part of the art establishment.

Many critics have commented on the lack of obvious technical skill in the Young British Artists' work. Despite this, they are among the richest and most commercially successful artists ever.

TANKED UP

Damien Hirst's conceptual artwork features animals preserved in tanks of formaldehyde, with the intention of demonstrating the fragility of life. Luckily for this cat, he's good at holding his breath and has most definitely NOT been pickled for posterity.

TURK HAIR

Gavin Turk's iconic piece, *Pop*, is a mash-up of a Sid-Vicious-esque figure, imitating the pose Andy Warhol used for his own Elvis Presley portrait. An ironic comment on the nature of celebrity and the commercialization of artists' work, *Pop* represented Turk's own version of Pop Art.

GLITTER WHILE YOU WORK

Chris Ofili is an artist renowned for using unusual materials in his work, making use of collage, glitter and even elephant dung. These controversial, high impact works are typical of a movement that wanted to shock.

stroke me tickle me feed me treats

NICE 'N' NEON

Tracey Emin has used neon lights throughout her career as a way of expressing emotion, mainly using simple yet poetic phrases that the viewer can easily connect with.

'I can't wait to get into a position to make really bad art and get away with it.'
Damien Hirst

SPOT THE DIFFERENCE

Hirst's 'spot paintings' are among his most famous. They were designed so that the colours would be complementary, but never repeated. Each painting was created by hand, but made to look as though they could have been created by machines.

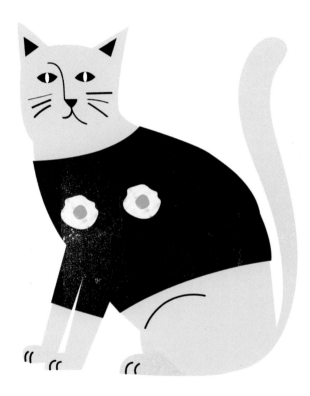

SUNNY SIDE UP

Controversial Young British Artist Sarah Lucas is renowned for her sense of humour. She used fried eggs in various suggestive pieces, intending to raise questions about sexuality and gender stereotyping.

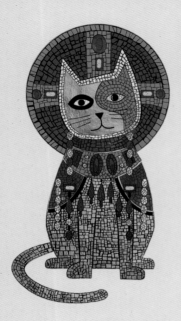

A FELINE TIMELINE

FOLLOW THIS TIMELINE OF THE ARTISTS AND MOVEMENTS THAT FEATURE IN THIS BOOK.

ANCIENT EGYPTIAN
Pre-500

→

BYZANTINE
330–1400s

→

RENAISSANCE
1400s–1700s

Leonardo da Vinci
Michelangelo
Titian
Johannes Vermeer

—

ART DECO
1920s

A.M. Cassandre

←

MAGIC REALISM
1920s

Frida Kahlo
Alexander Kanoldt
Franz Radziwill
Alberto Savinio

←

DE STIJL
1917

Piet Mondrian
Theo van Doesburg

←

DADAISM
1915

Hans Arp
Hugo Ball
Marcel Duchamp
Hannah Höch
Francis Picabia
Kurt Schwitters

←

SURREALISM
1920s

Salvador Dalí
Max Ernst
René Magritte
Joan Miró

→

ABSTRACT EXPRESSIONISM
1940s

Willem de Kooning
Wassily Kandinsky
Franz Kline
Lee Krasner
Barnett Newman
Jackson Pollock
Mark Rothko

→

COBRA
1948

Karel Appel
Constant Nieuwenhuys
(Constant)
Asger Jorn
Cornelis van Beverloo
(Corneille)

→

POP ART
1950s

Richard Hamilton
Roy Lichtenstein
Andy Warhol

—

ROCOCO
1730

François Boucher
Jean-Honoré Fragonard
Jean-Antoine Watteau

IMPRESSIONISM
1860s

Edgar Degas
Claude Monet
Pierre-Auguste Renoir

POST-IMPRESSIONISM
1880s

Paul Cézanne
Paul Gauguin
Vincent van Gogh

CUBISM
1907

Georges Braque
Juan Gris
Fernand Léger
Pablo Picasso

FAUVISM
1905

André Derain
Henri Matisse
Kees van Dongen

SYMBOLISM
1880s

James Ensor
Gustav Klimt
Edvard Munch

POINTILLISM
1880s

Georges Seurat
Paul Signac

MINIMALISM
1960s

Sol LeWitt
Donald Judd

GRAFFITI
1970s

Jean-Michel Basquiat
Futura 2000
Keith Haring
Kenny Scharf

YOUNG BRITISH ARTISTS
1988

Tracey Emin
Damien Hirst
Sarah Lucas
Chris Ofili
Gavin Turk

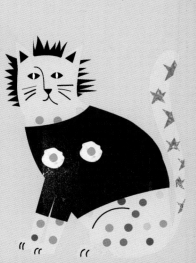